"Instead of worrying about what you cannot control, shift your energy to what you can create.".

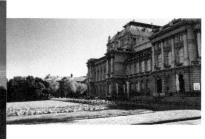

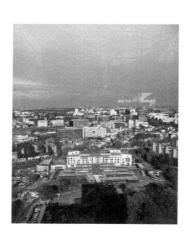

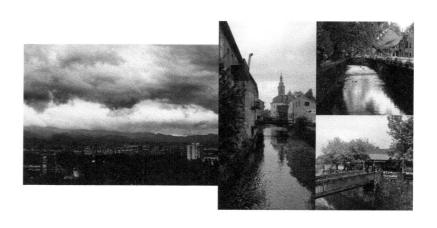

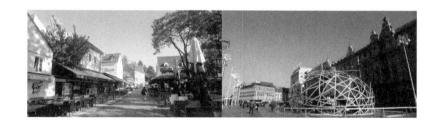

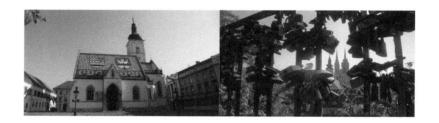

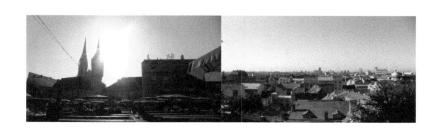

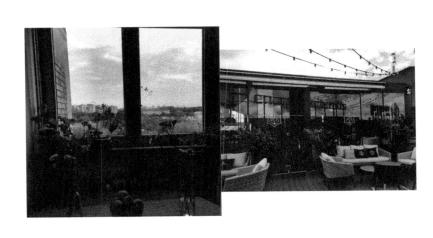

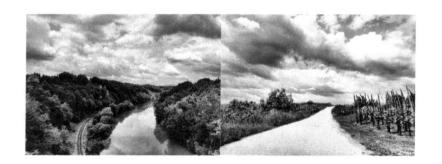

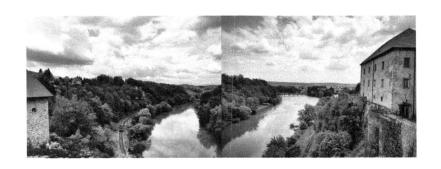

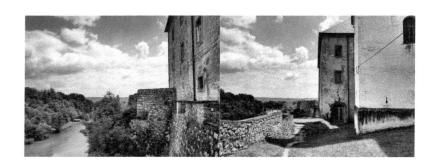

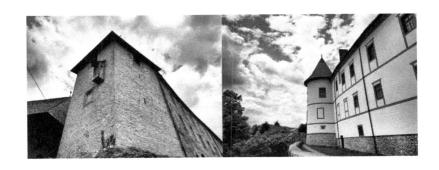

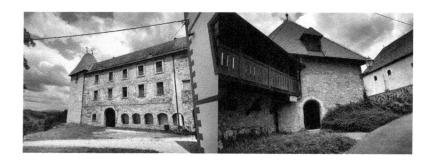

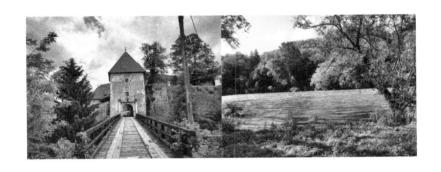

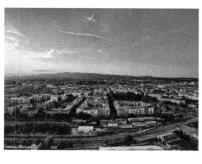

Flight Price from Sljeme to New York Might Surprise You Promoted [Flight Prices | Search Ads ©

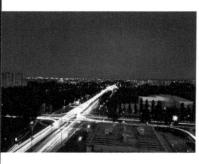